Route 22

Benjamin Swett
Route 22

THE QUANTUCK LANE PRESS NEW YORK

Route 22
Benjamin Swett

Copyright © 2007 by Benjamin Swett
Foreword copyright © 2007 by Robert Stone
Painting on page 55 copyright © by Will Moses. Reproduced here with permission of the artist.

All rights reserved
Printed in Italy
First Edition

Publication of this book was partially underwritten by a grant from Furthermore: a program of the J. M. Kaplan Fund, with the support of the Columbia County Historical Society.

Book design and composition by Laura Lindgren
The text of this book is composed in Berling and Trade Gothic.

Manufactured by Mondadori Printing, Verona

Library of Congress Cataloging-in-Publication Data
Swett, Benjamin.
 Route 22 / Benjamin Swett. — 1st ed.
 p. cm.
 ISBN 978-1-59372-026-1
 1. New York (State)—Pictorial works. 2. New York (State)—History, Local—Pictorial works. 3. United States Highway 22—Pictorial works. 4. Swett, Benjamin—Travel—New York (State) 5. New York (State)—Description and travel. 6. United States Highway 22—Description and travel. 7. New York (State)—History, Local. I. Title.
 F120.S94 2007
 974.7'044—dc22 2007000913

The Quantuck Lane Press | New York
www.quantucklanepress.com

Distributed by
W. W. Norton & Company
500 Fifth Avenue
New York, NY 10110
www.wwnorton.com

1 2 3 4 5 6 7 8 9 0

To Katherine

Foreword

Benjamin Swett's study of New York's Route 22 is a highly original and personal work. In spite of the fact that 22 remains one of the northeast's more scenic and historic roads, Swett's pictures and brief accompanying essays are a world away from conventional prettification. They are rather the illustrated journal of a thoughtful traveler contemplating variously the remnants of a lost age of hardscrabble farms and mill towns, at once idyllic and brutal, and the tacky innovations, already ruinous, of the late twentieth century. He includes as well some portraits of people whose lives are stretched along NY 22's length. This is a haunting and insightful work that transcends the picturesque to approach the profound.

<div style="text-align: right">Robert Stone</div>

Route 22

I

In June 1998, I happened to drive my daughter up to Vermont to spend a week with my parents, and I decided to return to the city down the old state highway known as Route 22. It was one of those hot misty days when the air is so humid that the sun never seems to shine, and you can't rightly distinguish the earth from the sky. Everything looked just a little changed from the way it usually does—enhanced, somehow—and I found myself continually stopping the car and getting out to look around.

The first town I came to was Hoosick Falls, a depressed-looking place with an offtrack betting parlor, a tattoo emporium, and a lot of Laundromats. A mansard-roofed building that looked like a former hotel suggested a grander past. American flags hung up and down the main street in honor of the upcoming Fourth of July. A rambling Victorian, nearly hidden under overgrown pines, advertised itself as "Miss Olivia's British School of Ballet." A sign proclaimed that in 1987 the town had received an award for having the best-tasting water in New York State. It was the kind of upstate New York town I was always driving through and saying to my wife, we should come back here some time, and then we'd drive on and get involved in something else and forget all about it. I was about to do the same with Hoosick Falls when a state historic marker informed me that the American primitive painter Grandma Moses had been born nearby. She had been first "discovered," the sign said, in a drugstore in the village, had done most of her important painting in the area, and was buried in a cemetery just outside town. My wife's aunt and uncle had a painting by Grandma Moses, called *White Christmas*, in their front hall. It was hard to reconcile the happy scenes I remembered from the painting with the place I saw before me today.

That night, as I continued south toward New York City, I kept noticing the contrast between the landscape I could see through the car window and the one I remembered from paintings by Grandma Moses. I had always accepted her paintings as imaginative reconstructions, but I now understood that my own image of upstate New York was just as unrealistic. I'd grown up with idea of the Harlem and Hudson Valleys, Lake George, the Adirondacks, and the country farther north as the province of the romantic and the picturesque. My views had been formed not so much by Grandma Moses as by James Fenimore Cooper, Thomas Cole, Frederic Church, and Antonín Dvořák. Was there anything left of those ideas, or were they all gone? It seemed to me that something else was operating here now and I wondered if it had always been here and had just been ignored by those romantics or if it was something new that had emerged more recently.

I began looking around a little more closely and came to the town of Berlin. It was Sunday but the W. J. Cowee Mill was open, smoke puffing from two different pipes as the company worked away producing wooden beads, napkin rings, candle holders, yo-yos, and other wood-turned products, as some literature I found in a doorway explained. I took down the phone number of the mill, thinking that I would like to come back some day, when I had more time, and view the interior of the plant. I had never watched a yo-yo being made and I thought it might be interesting.

A peaceful, empty feeling pervaded Berlin, as if everyone had gone off to watch a ball game in another town. I passed a house that had just been spray-painted. Opaque, empty, ideal in a way, tape still around the windows, a ladder poised on the roof, pointing at the sky, it seemed to wait there at the side of the road for its owners to return. I wondered who the owners might be and why they had built their house so close to the road. Was it an old house that had stayed in one spot while the road gradually widened? Or a new one erected by somebody who craved proximity to traffic? Or had Route 22 been relocated from some narrower, more twisty spot and laid just here? I moved on. I felt restless and anxious, and at the same time stimulated by the views opening up in the gray light. Wanting to stay and explore these places further, I also wanted to keep going and see what else I would find before it got too dark.

I left Berlin and continued south. At a pick-your-own-strawberries place, people of all ages stooped to harvest fat, red fruit. It was two days after the solstice, and the difference between darkness and light seemed to stretch out and divide into infinitesimal increments. I pulled over and climbed onto the roof of my car to take a picture. It felt good to have a camera in my hand again. In high school and the first years of college I had thought of myself as a photographer and had carried a camera everywhere. Then, halfway through college, I decided that I was a writer. I thought that I must make a decision between writing and photography, and eventually I chose what seemed to me the more difficult career. Standing there on the roof of my car in the absolute silence of that upstate Sunday evening, I questioned whether difficulty was the best criterion to use in choosing one's career. Pleasure might be a better one.

Near Austerlitz, a garage had been turned into a sculpture studio. Irregular patterns of polished steel gleamed in the dusk. A screen door slammed and a woman with long dark hair, in a dark dress with white horizontal stripes, emerged from a house that needed a coat of paint. A man, tall, with fluffy graying hair and shirt unbuttoned halfway down, appeared from the garage with a welder's protective helmet in one hand. "My name is Bijan," he said, reaching out with his other hand. "I am Barbara," said the woman. Bijan was from Iran, a sculptor who reconditioned cars to support himself. Barbara was also an artist and lived with her mother across the state line in Pittsfield. "You may have heard of him, everyone knows him around here," Barbara said about Bijan. I explained that I was not from around here. "What're you, a photographer?" "I'm doing a project on Route 22," I said, though I had not known until that moment that I was.

Bijan and Barbara wished me luck, and I kept going. Inside a barn, electric light shone garishly on the backs of some cows. Outside, the fields not so much darkened as took on increasingly fine shades of gray. Gray shifted to gray and the view reduced itself to lines, until the Queen Anne's lace shone blue and the chickory white. It was so dark, nine o'clock, yet so light at the same time. Bats fluttered about and crickets sang in the purple loosestrife and the hay. There were smells of dung and hay and corn, and in their square of electric light the cows lowed and chewed. I suppose you could say that everything was still, as if frozen, yet simultaneously in motion, gnats in a mist of activity among the cattails, and that sharp clear call of the red-winged blackbird. There was something sad and at the same time exhilarating about it. This, I thought, is closer to what I'm looking for, though what I was looking for I couldn't exactly say.

II

Without really meaning to—as a vague sort of experiment—I began going up Route 22 on other trips and taking pictures. When I had a couple of days I would drive up to a section of the road and start looking around. My wife and children were relatively tolerant of this new interest as long as I didn't stay away too long or try to drag them into it. We were renovating our apartment that year and our lives were a bit chaotic anyway, and my wife and I had some other problems. I suppose Route 22 became something of an escape for me, but I was drawn to it for other reasons.

 I grew up in Brooklyn. One day, when I was twelve, my parents and sisters and I rode our bicycles across the Brooklyn Bridge. We came out on Park Row and headed north onto the Bowery, a wide street that was difficult to navigate because of the cobblestones. "See this street?" my mother said rather casually. "It goes all the way to Canada. It's Route 22." The idea that a city street so close to our front door could lead to places so far away seemed to put my small experience into a larger perspective. As I grew older, I learned that that perspective was much larger than I had realized. The transportation corridor between New York City and Canada, first by water, then by rail, and finally by road, had once been considered of international significance. At one time or another, the Iroquois, the Algonquins, the French, the English, and the Americans had all vied to control it. Taking over this route, and cutting New England off from the rest of the continent, was a strategic goal of the French during the Seven Years' War and of the English during the American Revolution and the War of 1812.

A couple of weeks after my first trip I headed up Route 22 again. According to the map, Route 22 officially begins in Mount Vernon, in southern Westchester County, where the White Plains Post Road breaks away from the Boston Post Road and heads north. But I did not feel entirely wrong in sticking to my mother's view that Route 22 actually begins farther south, at the southern tip of Manhattan, and follows Park Row, the Bowery, and Third Avenue north across the Harlem River to the Bronx, then continues along the old Boston Post Road (here called, simply, Boston Road) to Mount Vernon. Ways of travel, routes of human migration, are larger and more obvious than the road signs people happen to place along them, and these are the oldest roads out of New York. As I was to discover, the numbering of the state highways at the beginning of the century was itself a haphazard and often shifting accommodation to existing conditions. State transportation officials applied the number 22 to several different routes before settling on the one we know now. Even as late as 1940 the *WPA Guide to New York State* called Fifth Avenue Route 22.

As I came into the Bronx and looked out the window, I remembered that the Boston Post Road is one of the oldest highways in America. It was started by the English soon after they ousted the Dutch from New York, and most of the founding fathers traveled along it on horseback as they made their way up and down the New England coast — George Washington, John Adams, Benjamin Franklin, Benedict Arnold. I wondered what they would think if they could see it now.

I came to West Farms, an early village in the Bronx, and stopped to look at the elevated tracks of the IRT subway line. For nearly a century these tracks have carried people at rushing speeds over the heads of neighbors whom they don't know. Settlers began erecting mills along the Bronx River here in the 1700s. By the early 1800s, the village of Ten Farms had formed at what is now the intersection of Boston Road and East Tremont Avenue. The village later adopted its current name. For many years, the Bronx River was navigable up to West Farms and boats used to come up to trade.

The Bronx River still flows through West Farms and under the tracks of the IRT. It is the only freshwater stream of any significance in the five boroughs of New York City. According to my friend George Colbert, it was considerably larger before the Kensico Dam, in North White Plains, siphoned off a quarter of its flow to provide water for New York City in 1915. There is a legend that during the American Revolution the British mistakenly thought the Bronx River navigable to White Plains. The War Office in London ordered Admiral Richard Howe to sail his warships upriver and attack American boats. Unexpectedly grounded near Hunts Point, at the mouth of the river, Howe had to turn back. The tangled brush and clinging grapevines along the river are also thought to have helped stall the admiral's brother, General William Howe, in his advance on Chatterton Hill, near White Plains, in October 1776. Howe won the battle but advanced no farther. The river is named for Jonas Bronck, a Swede who set up a fiefdom along it in the 1600s. An 1817 poem by Joseph Rodman Drake called "Bronx," which celebrated the waterway in iambic pentameter, became so popular that people ended up applying the name of the river to the land on either side. That is how the borough got its name.

Continuing northeast on Boston Road, I took a detour into Pelham Bay Park. I like to visit Pelham Bay Park in the morning and stand on the bridge over the Hutchinson River to look at Co-op City in the sun reflecting off Long Island Sound. In the late 1960s and early 1970s, my sisters and I watched the development rise through the windows of our parents' station wagon as we drove past on our way to visit our grandparents in Westchester. Ground was broken for the thirty-five buildings in 1966, when I was seven. It is said that so many people took advantage of the low purchase prices of the apartments that Co-op City single-handedly wiped out several Bronx neighborhoods. Today, about 55,000 people live there.

 Before 1966 an outdoor theme park called Freedomland occupied the Co-op City site. Its theme—American history—apparently failed to attract much interest and the park was closed. Three hundred and twenty years before that, the land had belonged to Anne Hutchinson, a Puritan midwife who had been banished from Boston for her unorthodox interpretations of the Bible. After her husband died, she and her thirteen children had moved here, to what was then a wilderness northeast of the Dutch colony of New Amsterdam. She had begun building a farm when local Indians murdered her and many of her children and followers.

I hurried up through Yonkers, White Plains, Armonk, Bedford, and Katonah with a feeling of regret about all the places where I could not stop. My grandmother, who still lived in northern Westchester, just off Route 22 in Goldens Bridge, was expecting me for lunch. She sat at her usual end of the table, with its view down the field to the pond, and fed me her usual meal of raw hamburgers, Dubonnet, and salad. She was eighty-nine, and had recently been told by the man to whom she had sold the house after my grandfather died that she had to leave. Her lease had run out and, according to my grandmother, the landlord wanted his daughter to live there now. Nobody in the family had realized that the lease was not for my grandmother's lifetime and it was unclear where she was going to go or what she was going to do. My mother and her sisters had begun looking into retirement homes, and there was even talk of her moving, like King Lear, from daughter to daughter each year, but nobody quite favored that option.

Hanging on the wall behind her were portraits of my grandfather's grandfather and great-uncle. The great-uncle had died, childless, in 1862, at the age of twenty-seven, of wounds received at the second battle of Bull Run. The grandfather had died in 1880, at forty-nine. During lunch, my grandmother told me that the landlord and his daughter had been to the house a few days before, looking around. From her chair in the living room she had heard them in her bedroom directly above, talking in low tones. She thought that they were talking about how they were going to rearrange the room after she was gone. She had lived in the house for thirty-three years.

After helping my grandmother with the dishes, I excused myself and walked down to the pond. In his later years, my grandfather had carried on a dispute with a neighbor who lived on one of the hills above the pond. The neighbor also had a pond, and in the neighbor's pond were bass. It was my grandfather's contention that the bass swam down the stream and ate his trout eggs. He had built his pond and stocked it especially with trout, and not only had he begun catching bass instead, but when he experimentally drained the pond he found that it contained a few fat bass and nothing else! The neighbor, a tough man who owned and operated a fleet of bulldozers, proved unmoved by my grandfather's phone calls and letters. Rather than enter into litigation, the old man hired somebody else with a bulldozer to dig a series of "silt traps" above the inlet to his pond, and in these watery holes he installed chickenwire to stop the bass from swimming through.

 Just how successful the silt traps proved we never found out. My grandfather had begun fishing less and less. Eventually he took to simply sitting in an iron chair at the side of the pond, sipping Dubonnet and taking occasional peeks at the newspaper. Walking to the pond became a strain, but his doctor insisted that he keep it up. We placed chairs at intervals between the house and the pond so that he could rest along the way. To help support him into and out of the chairs, we screwed door handles into the trunks of trees. After he died, the door handles remained but began to disappear inside the trunks as the trees grew around them. If I were to go back there now, I am sure that the handles would be gone entirely, grown inside the trees, and only I would know that they are still there. But the property is no longer in the family and I have no reason or desire to return.

I said good-bye to my grandmother on her steep, looping driveway, with its smells of peat moss and cedar, and got back on Route 22 and continued north to the Watchtower Education Center in Patterson. The Jehovah's Witnesses had recently completed this new facility, designed to promote global Bible instruction and train missionaries. When my wife and I had driven by a decade earlier, it was still a farm. I parked in a clean new lot and crossed a bright turnaround where a couple of tour buses idled. Inside the lobby, Austrians of all ages mingled in family groups, signed in at an information desk, and examined, through the Plexiglas that covered it, a scale model of the Temple in Jerusalem. I picked up some brochures for further study, made use of the bathroom, and headed back to my car. As I was crossing the turnaround, one of the Austrians, who had gone quite far back to try to fit the twenty-eight buildings into the lens of his camera, noticed the doors of one of the buses closing. Panicked, apparently, at the thought that the bus might drive off without him, leaving him alone so far from home, without a ride in the vast midday of Patterson, he broke into a run.

Roughly two-thirds of Route 22, from Manhattan to Granville, follows a longitudinal furrow in the New York landscape known from Dutch times as the Harlem Valley. Down this indentation drovers prodded herds of cattle to New York City for the slaughter. It is said that the black line on the map that is Route 22 today was printed originally by the hooves of those cattle in the dust. Cattle not only helped create this southern stretch of Route 22 but also contributed, in a different way, to the economy of the region through which it passes. While New York State as a whole seems particularly well suited to dairy farming, the extension of the train line north through Brewster in the 1850s and Gail Borden's invention, at about the same time, of a process to condense milk commercially opened up immense new markets for Harlem Valley milk and helped turn the region into a kind of mammary gland for New York City and the nation. (With a government contract to supply milk for Union soldiers during the Civil War, Borden's factory in Brewster allowed soldiers from Pennsylvania to drink milk in Virginia originally pulled from cows in Hoosick Falls.) To this day, at least along the northern parts of this southern section of Route 22, traffic is still stopped by boys herding cows for the evening milking.

At Wingdale, I pulled in to the Harlem Valley Psychiatric Center but the place was empty, the grass unmowed and the trees unpruned. A branch had fallen into the middle of the road and nobody had bothered to pick it up. DANGER. KEEP OUT. HAZARDOUS AREA, read a sign on the door of one of the buildings. The paint on the door was flaking off, Queen Anne's lace shot up from cracks in the steps, and untrimmed bushes smothered the railings. Except for the cars passing by on Route 22 all was silent. As a child driving by, I had wondered what went on behind those barred windows, beneath those overhanging trees. It was one of the places you passed on Route 22. Now I would never find out. As it turned out, the state of New York had closed the psychiatric center in 1994. A developer bought the property in 2003 and planned a new community for empty nesters and young couples without children. There was to be a new main street, stores, and a golf course, all within walking distance of the Metro-North train line.

A few miles farther along, at Dover Plains, I passed a sign for the Old Drover's Inn. My wife and I liked to go to the Old Drover's Inn on our anniversary. The rooms have neither televisions nor phones but the fireplace in each room works and the tavern in the basement, dark and private, has that distinct smoky smell that is supposed to come from years of cooking fires. The inn opened in the 1750s and was part of the Harlem Valley cattle route, providing rooms and the tavern for drovers and space outside for "ankle beaters"—those who actually walked with the livestock—and the cattle. The Marquis de Lafayette supposedly stayed here for a short time during the revolution. Elizabeth Taylor and Richard Burton came after the filming of *Cleopatra* in 1962. It was the kind of place that made one think of having an affair.

 As I drove past without stopping, I realized that my wife and I had not gone that year. She had a conflict, I had a conflict, we couldn't get a babysitter: I couldn't remember the exact cause but it didn't matter. Things were not as they should be between us. Her career had come to a stop and she blamed me for it. With time on her hands, she spent long hours knitting sweaters, practicing her harpsichord, and reading by herself at a café in the Metropolitan Museum. She had started a book club with one of our male friends and begun going to poetry readings with him. It is possible, under the routines of marriage, to ignore things for long periods of time, and I was doing my best to ignore the fact that we were drifting apart.

At Bijan Mahoodi's sculpture yard, in Austerlitz, I stopped to photograph Bijan polishing one of the whimsical steel structures that amuse drivers as they pass. I had called Barbara Arpante, Bijan's girlfriend, to make the appointment, and I spent a long time with him. It was strange seeing the place in the broad afternoon light after having seen it before only at dusk. The light was too strong but the grasshoppers were going like mad and the air had that searing brightness of the time of day when people become sleepy and there is still possibility. "Have you been to the Millay colony yet?" he asked at one point. On my earlier visit, Barbara had told me about the artists' colony a few miles away, on land that had belonged to the poet Edna St. Vincent Millay. "I'm thinking of sending them an application." "Good idea. They might like your project." It astonished me to think that, in Bijan's mind at least, the project already existed.

The day was almost over when I came to Olivia's British School of Ballet, in Hoosick Falls. Nobody answered the door and, deciding that the school must be on summer break, I set up my camera on the roof of my car and started to photograph the house. As I was focusing, I kept hearing, from down the street, the insistent yet somehow anxious voice of a shirtless, muscular man about my age, who was throwing a football to his very small son. "Do it like this—naw—like this," he kept exhorting in his cracked, strained voice. A huge dog, low to the ground, with smooth hair, short legs, and a strange black-and-white coloring swarmed about their feet, her pink teats swinging over the dirt. After I had taken the pictures, I walked over and asked the man what kind of dog it was. "American pit," he said. "Nice coloring," I answered, but in truth it frightened me.

I spoke with Olivia Sumerlin, the owner of the ballet school, on the phone another time. A "professional dancer and high-fashion model" from England, Mrs. Sumerlin had met her husband, a minister of the Church of Christ, in Spain. Among the adventures of their marriage had been acting as extras in the James Bond film *On Her Majesty's Secret Service*. After they had lived for some years in southern California, the Reverend Sumerlin applied for a job as a preacher in Bennington, Vermont. They moved to Hoosick Falls in 1976. Mrs. Sumerlin opened her school a year later. When I spoke with her in 2003, her husband had died and she was teaching, with no assistance, one hundred students a week. Parents drove their children from as far as fifty miles away. Students she had taught had become professional dancers. Quite a few, she said, had been in the summer program of the New York City Ballet.

I spent the night at a motel in Bennington, Vermont, and the next morning continued north to Eagle Bridge. Will Moses, the great-grandson of Grandma Moses, lives in his great-grandmother's house in Eagle Bridge, makes paintings in her style, and sells them from a gallery in her old barn. I had read about him in a guidebook and thought he might be able to shed some light on my questions about the New York landscape. While an assistant went to find him I examined one of the oil paintings hanging in the gallery. It was called *Washington County* and included many of the landmarks of the county—Lake George, Lake Champlain, the Champlain Canal, the slate quarries of Granville—all shown at a mythic moment of perfection on the day of the county fair. The picture was priced at $15,500. The gallery contained three or four oil paintings of other subjects, in a similar style and with similar prices, and numerous reproductions in the form of prints and greeting cards and illustrated books and even a jigsaw puzzle. I kept coming back to *Washington County*. I was about to drive up through there and I was reminded of all my questions about the differences between what I saw and what others did.

When Will Moses came down, I asked him about the Grandma Moses that my wife's aunt and uncle had inherited. Would it have been specially commissioned or had Grandma Moses painted it for her own pleasure and then sold it? He said he did not know. He really wasn't an expert on his great-grandmother, he explained. He led me upstairs to his studio overlooking his great-grandmother's house and we spoke about Hoosick Falls and how Route 22 runs right through the middle of it and trucks have to turn dangerously at two of the main intersections, and how traffic patterns and vehicle types have changed. He said there had been a plan to build a bypass around the village but that it had fallen through. During Prohibition, he said, Hoosick Falls and Route 22 had been important links in the supply line of liquor from Canada to New York City. A quiet, deliberate man, he seemed a cross between a New York dairy farmer and a Byzantine icon painter. Like those ancient monks, he considered himself primarily a craftsman, someone who had stuck to the family line of business because that's what Moseses did. It was his grandfather who had encouraged him to paint. He remembered his great-grandmother more as a nice old lady than as any kind of artistic influence. Coming to my point, I asked him how he deals with the difference between what he actually sees in the New York landscape and what he must see in his mind's eye. "What I try to do when I paint a painting," he said, "is to make an attractive painting, one that will appeal to someone else down the line. Part of my job is not to be one hundred percent faithful. You want to have a little bit of an ability to interpret and improve upon nature."

Afterward, as I continued north toward Cambridge, New York, I thought about what Will Moses had said. As a photographer, I didn't have much of an ability to improve upon nature. I could choose what to photograph and how to frame it, but I couldn't change it. I was mulling this over when I came to an abandoned diner. It seemed to have been lifted up from some other location and plunked down just there, at the side of Route 22, a specialized organization of metal that had passed its time of use and nobody knew quite what to do with anymore. I saw how it was collapsing into the ground, how branches and plants were flourishing inside it, how birds and animals were making it their home. It was not the sort of object I felt Will Moses would include in one of his interpretations, but I felt that I could include it in mine.

 A year later, I happened to pass that same spot and the diner was gone. The grass had regrown in the place where it had lain and the trees inside it had been removed. I called Don Cummings, a former supervisor of White Creek township, to ask where it had gone, and he told me that he himself had overseen its removal. "It was there for eighteen years," he said. "It kept deteriorating and was becoming a hazard. We cleaned it up." Mr. Cummings said he did not know why the diner had been left there, what purpose it had been supposed to have, or whether somebody had intended to fix it up and open a restaurant at that location or simply junked it there. "We cleaned it up," he said. "That's all I know." As I was putting this book together, however, I learned that the story of the diner wasn't over. A Cambridge man, in the Midwest on business, had rediscovered the diner at the side of a road in Michigan. Someone had transported it out there and repaired it, and this man from Cambridge had eaten an excellent lunch there.

I was about to drive on when I noticed, across the road from the diner, a mound of dirt on which small plants had begun to grow. Around it rose other, similar mounds, shapely, perfect in form, ignored, mysterious. I did not think that these mounds would find a place in a Moses painting either but I liked them. There was nothing nostalgic or picturesque about them but neither were they ugly and I thought that they belonged in my landscape but I could not understand quite how. There was nobody about so I took a picture and drove on. A couple of years later I passed that same spot and, like the diner, the mounds were gone. In their place gleamed the green-and-brown modular units of a company that called itself Cambridge Valley Self Storage. Nearby, a man was rearranging some dirt with a very small bulldozer. I asked him if he knew anything about the mounds and he said he thought they had consisted of topsoil that the company that owned the property had scraped up to sell when the zoning changed from farmland to commercial use. The mounds, in other words, had been a transitory piece of perfection, a temporary by-product of the region's shift from the pastoral to the paved.

A short while later I came to Granville. What one notices, driving into Granville, are the heaps of waste slate on hillsides for miles around, from the quarries that have given the valley a reputation as "the colored slate capital of the world." The piles rise above villages, looking as if they were going to engulf people's houses in a cascade of small stones. According to a display at the Slate Valley Museum in Granville, the hills around Granville and up into Vermont once connected to Wales. The long, deep deposits in the two land masses on either side of the Atlantic are the same. Slate is quarried in other regions of the world, but the Slate Valley has one of the broadest ranges of color and one of the most abundant supplies. At the time I visited, thirty-five companies were operating one hundred quarries and producing $30 million of roofing and floor tiles each year. Slate is produced elsewhere in the world, but the red slate produced around Granville, I discovered, is considered unique. Because of the fragile structure of slate in general, quarrying is an inefficient operation, and more than seventy-five percent of the material from the ground becomes waste. But with red slate, more than ninety percent of what comes out of the ground becomes waste. I was glad to learn all this, because I had never thought about slate before. Later, I was to notice that red slate forms an important part of the patterns on the roofs of old barns and houses around Granville.

At Granville, Route 22 bifurcates. The original Harlem Valley farm road continues up its old peaceful furrow into Vermont, where it changes to 22A and passes out of this story. The other Route 22 turns west across a tableland of ranch-style houses and log cabin restaurants, dips down past the Great Meadows and Washington correctional facilities, enters a no-man's-land called Comstock, crosses the Champlain Canal, and swings north into the Champlain Valley.

Uniform, abandoned-looking warders' houses greeted me as I approached Great Meadows. The prison itself seemed to have been constructed in layers, and what looked like a castle from farther up the road appeared, on closer inspection, as a grimy palimpsest of various ages of walls—brick, painted-over cement, chain-link, razor wire. In a field beside the prison, a guard with a rifle vaguely watched a man cut grass with a tractor. Watchtowers of blue-green glass surrounded a courtyard from which faint shouts arose, their meaning indecipherable in the vast midday. I leaned out of the car window to take a picture. "Move out! No picture taking! Move out! No picture taking!" a voice blared from a loudspeaker on one of the watchtowers. I threw my car into gear and sped on past the second, smaller Washington Correctional Facility and, with a feeling of relief, crossed the Champlain Canal and turned north toward a dot on the map called Whitehall. Apparently, the guards in the watchtowers had thought that one of my photographs might help a prisoner to escape.

I followed signs to what appeared to be the fanciest restaurant in Whitehall, called Finch & Chubb at the Lock 12 Marina. It turned out to be a pleasant place with white tablecloths, Vivaldi's *Four Seasons* issuing from speakers in corners, and a list of locally brewed beers on a blackboard by the door. A waitress placed me at a table in the very middle of a row of windows overlooking the headwaters of Lake Champlain. I sat down and opened my sixty-year-old *WPA Guide to New York State*, the only guidebook to have much to say about Whitehall. "What about this silk mill?" I asked when the waitress brought me my sandwich. "Burned down." "When?" "In the sixties." "It says here that this is a big railroading town." "Gone," she said flatly and with a sudden quick smile turned away. Clearing away my dishes at the end of the meal, the waitress asked what I was writing in my notebook. I explained that I was doing a project on Route 22. "Have you been to the castle yet?" She pointed toward the ceiling, in a generally easterly direction. "It's really named Skene Manor but we always call it the Castle. They have a tearoom there." I wrote this down, impressed by her air of authority.

"You seem to know the town well." "I've lived here all my life." "Do you like it?" "It's quiet. Some people like that." "But not you?" "Oh, it's all right. I like the country." I couldn't tell whether she meant that the country was even more quiet than the town, or if she included the town as part of that general condition she liked known as the country. Either way, I felt that I wanted to talk to her further. "As I go along the road I like to speak to people about the places they live," I said, though not until that moment had I known that I did. "Would you let me interview you some time?" "Sure," the waitress said. I was amazed at her confidence. She was a skinny girl with a couple of silver earrings high in her left ear. I asked her how I could get in touch with her and she said she would write the information down.

III

Her name was Daphne Kingsley and she was nineteen. When I called her from the city a few days later to make an appointment to interview her, she suggested that we have breakfast some morning at another restaurant along the canal called the Liberty Inn. I was nervous about meeting her because she was pretty and I was afraid that this would distract me from my pure concentration on the road. It hadn't occurred to me that my concentration on the road could necessarily be pure, but already some things were striking me as more central to the project than others. And this was strange, because I still couldn't say to myself exactly what the project was. I told people when they asked that I was searching for the picturesque, and when they pressed further I modified this to the picturesque doubled back on itself. They never knew what to make of this and there I let the matter lie. One has to have a cover. It just didn't seem wise to tell the truth, which was that the project was an excuse to take pictures again. This would have sounded selfish, as if I were saying that the project was a ruse to be alone. It would have been honest, but people might not have understood. It may have been somewhat for these reasons that, unlike with my meetings with Bijan Mahoodi and Will Moses, I said nothing about my breakfast with Daphne Kingsley to my wife. It just didn't seem worth getting into. I left late after work one Wednesday and drove to Salem, south of Granville, where I had discovered a summer-stock theater that was putting on the musical comedy *I Do, I Do*.

I arrived early and got a seat near the front of the theater, which had once been a church. I did not know the play and as it started I was initially more concerned with photographing than with watching it. As the scenes unfolded, however, a painful feeling came over me. *I Do, I Do* follows the fifty-year course of a marriage, from initial euphoria over setting up a house and having children through disillusionment and depression in middle age to renewed and deepened love in old age and grandparenthood. Quite far into the play—during the disillusionment stage—the wife announces to her husband that she doesn't love him anymore and has fallen in love with a young poet. This reminded me of my wife's relationship with our friend of the book club. They were now constantly exchanging e-mails, ostensibly on literary topics, and going to poetry readings together. It occurred to me that even tonight, probably, as I sat here watching this play, my wife was at home, having just gotten the children to bed, exultantly e-mailing our friend. Was this really just some minor distraction, a "friendship of words," as she put it, that had no bearing on the day-to-day running of our lives? Or was it something more? Whenever she had printed out one of his e-mails for me (she liked to share his witty sayings) I had been reassured by the relatively impersonal subject matter—Henry James, Wittgenstein, Emily Dickinson—and by my wife's ease in showing it to me. But the flush that came into her cheek sometimes at the computer, when she opened her e-mail to find a note from him, was hard to ignore, and my sense of reassurance was short-lived. In Goethe's *Elective Affinities*, two couples end up reattaching themselves in new ways as their higher spiritual bonds, discovered through conversation, override more conventional marital ones. Was it a coincidence that our friend had suggested this book as the first reading for the book group he had started with my wife?

After the show, I milled around eating cheese and crackers served by a pair of girls in sashes that read "Washington County Dairy Ambassador." Then I headed off toward Whitehall. Smells of manure, hay, and earth poured through the windows of my car with sounds of crickets, and I drove fast because it was late and I had booked a room at the Lock 12 Marina and had to be there before eleven p.m. The play had ended with a reconciliation between husband and wife and a great deal of laughter and clapping among the theatergoers of Salem. I told myself that it was just a play and I shouldn't try to link it up with my own life. Still, I couldn't stop thinking about it entirely. As I topped the rise over the Comstock valley, the Great Meadows Correctional Facility appeared far below and away from me, lit up like a sort of infernal amusement park in the night. Great Meadows and its across-the-road neighbor, the Washington Correctional Facility, I had learned, opened in 1911 and 1985, respectively. They employed nearly twelve hundred state workers and housed just under twenty-eight hundred prisoners. Together, they were considered the biggest employer in the northern part of Washington County. I did not remember seeing these two important structures in Will Moses's painting.

When the Champlain Canal, connecting Waterford on the Hudson River to Whitehall on Lake Champlain, opened in 1823, Whitehall replaced Ticonderoga as the transportation nexus of the North Country. Here goods from the south were unloaded from canal boats onto lake-traveling sailing ships and steamers, and raw materials from the north (lumber, iron ore, wood pulp, graphite) were loaded back onto canal boats to be carried south. It was a thriving, gritty place, with a long history dating from before the Seven Years' War, a place of warehouses and longshoremen and lumber jams, which also considered itself, because of its role in providing ships for Benedict Arnold in the Battle of Valcour Island, "the birthplace of the American navy." Now Whitehall was a town that the world had forgotten. Its main street, sprung perfectly intact from the 1850s, had been almost sucked dry of business and was beginning to totter into the canal that runs through the center of town. According to local residents, the main employers were the correctional facilities in Comstock, the local school district, and a plywood factory along Route 4 on the east side of town.

I spent a very comfortable night in a very small room at the Lock 12, and woke to find Whitehall shrouded in fog. A cloud seemed to have flopped over the streets and buildings, lending everything a historical vagueness. I was not supposed to meet Daphne for another hour, so I walked out along the canal with my camera. I remembered that it had been at about that hour, not far from that day of the year, in 1842, that Charles Dickens and his wife had disembarked from a steamboat to breakfast in Whitehall before climbing aboard a stagecoach for a "very hot day's journey" to Albany. This was the only mention of Whitehall in the *American Notes*, but given the tenor of Dickens's remarks about other communities in New York State it is probably just as well that he reported no more on Whitehall than the fact of breakfasting there. Still, his silence tantalized me. Was it that, sleep-deprived, disembarking at dawn, having to worry about the disposal of his bags, for once he had nothing to say? Or was Whitehall, sandwiched between Burlington and Albany in his busy itinerary, in fact too unimportant to merit a comment?

 I was back in my room a little before eight. I heard a rap on my door and there stood Daphne. She just appeared out of the fog, an apparition from the farmland, on an old black mountain bike that she yanked from the bushes and wheeled beside me to the Liberty Inn.

We sat outside on a small terrace overlooking the canal. We were the first customers of the day. A waitress opened an umbrella over us and took our order, and I began asking Daphne about her town. She spoke confidently and freely, as if she had been interviewed many times before, or had been waiting for an opportunity to talk about it with someone from outside. Whitehall was a drive-through town, she said. She loved the place, felt very attached to it—her family had lived here for a long time—but she didn't know if it was a place where she could live herself. So much of the town was going or already gone. There was the Silver Diner, for example, a local institution here since the 1930s, which had recently closed down. Had I seen the wreck of it, up by the intersection of Routes 22 and 4? There was the Champlain Silk Mill that I'd asked her about when I met her, formerly one of the largest buildings—and employers—in town. It was gone as well.

 A year later I learned from Carol Greenough, the director of the Skenesborough Museum, that the Champlain Silk Mill had produced embossed silk ribbon. It had been so successful that by the 1920s it had produced one-third of the spun silk in the United States. Considered a model employer, the mill had put in sports facilities for its workers and provided housing for female employees. In the 1940s, however, synthetic yarns began to replace silk, and silk spinning became obsolete. The mill closed in 1951 and its large empty building on the side of the canal burned down in 1966. Ms. Greenough showed me a postcard of the mill, and I recognized the spot where it had stood, on the east side of the canal along the road to the Lock 12 Marina.

Champlain Silk Mill Whitehall N.Y.

Daphne gazed past me toward the fog through which the sun was trying to break and asked if I had seen the Mobil Oil tanks farther down along the canal. Her grandfather had worked there, she said, loading and unloading fuel from barges. The tanks were empty now. I asked Daphne what the fuel was used for but she wasn't sure.

 Carol Greenough told me that the fuel had been bound for the U.S. Air Force base in Plattsburgh. After the air force decommissioned the base in 1993, the fuel barges—some of the last regular commercial traffic on the canal—stopped coming and the tanks were left empty. Many people I spoke with remembered the startlingly loud whistle of the fuel barges as one of the distinctive sounds of Whitehall and its loss as one more sign that something else—a commercial life, a connection to the larger economy—had been lost as well.

Then there were the railroad yards. The Delaware & Hudson had closed its famous Whitehall yards in the late 1960s, tearing down the roundhouse, demolishing the turntable, and burying or removing most of the rails. Only the brick repair shed and some outbuildings remained. For a century, the yards had been a regional center for the repair and maintenance of engines and cars. In the 1880s, according to a display at the Skenesborough Museum, as many as seventy-six trains passed through the Whitehall yards each day. So threatened were the owners of the freight boats on the Champlain Canal by the advent of the rail line that from 1848 until 1851—the first three years of rail service—the train from Saratoga to Whitehall was permitted to carry only passengers. From 1851, when the freight ban was lifted, until 1874, when the line north to Ticonderoga and Plattsburgh opened, Whitehall reigned as the central link in the increasingly sophisticated transportation chain connecting Manhattan and Montreal. Even as late as 1940, the *WPA Guide to New York State* was calling Whitehall a railroad town.

 Carol Greenough said that the D&H had closed its yards soon after the completion of the Northway in 1967. Railroad companies were beginning to consolidate then in response to the usurpation of rail freight by containerized trucks. When I visited, the site of the former rail yards was under the care of a commercial salt shipper. I found a pile of road salt inside a long brick building whose two doors were exactly the right size for train cars.

As we finished breakfast the sun finally broke through and the day became bright and blue. I sat there stunned by the thought of all the losses the town had sustained and the strangeness of this girl talking about them so matter-of-factly. I felt as if she were giving me answers to questions I hadn't even thought to ask. She kept reminding me of somebody, but of whom I couldn't say. Myself at that age maybe or, even more likely, my sister. I felt that I had met her before or was related to her in some way. This made me feel that I was related in some way to Whitehall and that its history was also somehow my own. Daphne said she was about to begin her sophomore year at the State University of New York in Plattsburgh. Her mother was the town clerk. Her father owned a garage that specialized in Arctic Cat snowmobiles. Her parents had been high school sweethearts but were separated now. She planned to major in cultural anthropology, she said, and hoped to travel to other parts of the globe, particularly Africa. At the same time, she was keen on organic farming and could see starting her own farm on her father's land in Whitehall. I wondered which path she would follow. "Whenever I speak to someone along Route 22," I said, "I like to take their picture. Is there somewhere you would like me to take yours?" "Sure." Again, that confidence. We agreed to meet on a bridge near her father's land on the Upper Turnpike road when I next came to Whitehall. Breakfast over, we somewhat formally shook hands, and I watched Daphne wheel her bike off toward the town clerk's office. There was something she wanted to say to her mother.

Following up on Daphne's suggestion, I drove over to Skene Manor, the tall, spired granite house on "The Mountain" on the northeast side of the village. A volunteer, Joanne Kessler, showed me many interesting pieces of furniture, dining tables, mantelpieces, beds, and other articles characteristic of turn-of-the-century local opulence, and described the construction of the house from local granite. What interested me most, however, was a room in the attic whose walls and ceiling had been papered with nautical charts of the world. Joseph Potter, the state supreme court judge who built the house, had put them up, Joanne explained, when his son joined the merchant marine, so that he could follow his son's progress around the world. The local preservation group known as Save Our Skene had bought the house only recently, she explained somewhat apologetically, and had not yet had a chance to fix up the attic, and had had to leave it in this unrenovated state. "It's really just a storeroom at this point," she said. But somehow — as with Whitehall itself — the lack of renovations only made the place that much more interesting to me, only aroused that much more my desire to decipher the almost random arrangement of the charts, which superimposed maps of countries on charts of seas and turned that half-disintegrated attic room, in that half-forgotten upstate town, into a kind of obscure watchtower on the planet.

In the ensuing weeks I came to realize that my initial concerns about Daphne Kingsley were groundless. My project was taking me places I never would have known if I had not just gone. Out of the fog of northern New York State—the North Country, as people around there called it—this engaging person and her curious town had entered my life. Alongside them, certain other things—my wife's e-mailing and the increasing complexity of our apartment renovations—seemed to matter less. A demolition team had passed through our apartment, tearing out walls, prying out ceilings, throwing hundred-year-old wooden studs onto heaps of plaster and lathing. The contractor kept asking for more money but made little progress in putting the place back together.

In contrast, it was a relief to think about the unrenovated integrity of Whitehall. I was intrigued by the town's topographical centrality that was yet meaningless in the modern economy, and drawn to its loss of place in the world. Except for the canal as a recreational attraction and the very informative historical museum, there was nothing to bring people to Whitehall anymore and very little to keep young people like Daphne from leaving. Those who still lived there had to work at increasing distances or less-rewarding jobs. I wondered what the future of the place could be.

Whitehall became a base of operations as I explored farther north along Route 22 and Lake Champlain. I visited Fort Ticonderoga. Occupied during three wars by five armies, the star-shaped fortress of earth and stone had been built by the French beginning in 1755 to guard the stream between Lakes Champlain and George, and subsequently been clung fast to by whichever nation considered itself in control of Lake Champlain. Along with what seemed a small number of tourists (given the number of spaces in the vast, cracked parking lot), I spent an hour among the walls and cannon of Carillon, as the French had called it. A couple of men in army uniforms and tricornered hats, with cigarettes in their mouths and extremely long rifles over their shoulders, strolled purposefully past me in the rain, and I saw that I had missed whatever reenactment had taken place that day. Rain began to fall steadily and I strolled into the gun room and gazed at the variety of instruments with which human beings killed and wounded one another in the seventeenth and eighteenth centuries. Outside, children chased each other through roofless stone corridors and grass-filled rooms while their parents walked under umbrellas with guidebooks in their hands. A smell of balsam and wet grass lingered in my nostrils after I had left.

I drove up to Crown Point, where the French had built another fort that was later taken over by the English. A father and son were using a tripod of cedar poles to lift an engine out of a pickup truck. "What do you lift your engines out with?" asked Jerry Laribee when I expressed interest in a procedure I had not seen before.

I headed back down to Whitehall and came across a barn. It had a slate roof like all the old barns and the slate was falling off and the walls were cracked but the barn was still very much in use. Standing in the door was a calf; running around in front of the calf and through its legs were chickens; scurrying around among the chickens were dozens of chicks; and sitting on a rock in the middle of the chicks was a lazy yellow cat. From a blue house across the street walked a man. He said his name was Carl Pratt and that he had fifty calves and two hundred cows. He asked if I was from the *Post-Dispatch*. When I said I was doing a project on Route 22, he said apologetically that he needed a new roof on his barn but he had a lot of animals to look after. It was quiet up there on the Upper Turnpike road. I asked Mr. Pratt some questions about Whitehall but he didn't have much to say. He had no idea when the silk mill had burned. A lot of people used to work there, though, he said.

Five years later, I drove past Mr. Pratt's place again. The barn was standing and the dogs and cats and chickens were still running about as they had been, but the blue house across the street had burned to the ground. Nothing remained but the front steps and some charred beams and lathing sticking up among rows of unused farm equipment. Mr. Pratt came out from the barn and shook my hand but he didn't remember me. The fire had started in the furnace, he said. He now lived in a trailer that he owned up the road.

I met Daphne on the bridge that led to her father's farm. The bridge had been a favorite meeting place for her and her twin sister and cousins when they were younger. On hot days, before the creek started to fill with algae, they had liked to jump off the bridge into the creek. When they turned fourteen, they had spray-painted their names on the sides of the bridge. Her father and one of his brothers had inherited farms along the Upper Turnpike road from their parents. It had been several generations since farming had been the Kingsleys' primary business, but they were still strongly attached to the land. In 1914, Daphne's great-grandfather had started the first Ford dealership in Washington County, along Route 22 on the south side of Whitehall. The family had kept the business for sixty-eight years, until 1982. Daphne's grandfather had died and her father and two uncles wanted to bail out. Her father bought his garage, and the uncles got jobs as guards at the prisons in Comstock. But they had all passed their love of the land along to their children and continued to divert substantial chunks of their incomes to pay the taxes on it. As I was photographing Daphne it started to rain, a light drizzle bringing out the tar smells in the road. I asked her if I could look her up when she was back in school in Plattsburgh, if I happened to make it up there, and she said she would be happy to show me around. Barefoot, carrying her clogs, she walked back up the wet road to her father's house.

Later, I drove out and visited Daphne's father at his garage. Orson Kingsley specialized in the sale and repair of Arctic Cat snowmobiles. As a conversation starter, I told him I'd like to come back in the winter to experience the snowmobiling on Lake Champlain. "You can use snowmobiles in the summer," he said. When I looked doubtful, he led me into his office and showed me a videotape of people driving snowmobiles across water. "It's a contest," he explained. I watched snowmobile after snowmobile churn around an island on a pond. "One of the goals is not to sink." Whitehall had hit its bottom during his lifetime, he said, but it was slowly coming back. Most of its businesses had moved away to regional malls such as those in Glens Falls. "You can't even buy a pair of underwear here anymore," he said. "You can quote me on that." He seemed to know everyone who drove by and kept waving at passing cars. Reflected in his glasses was the long low fringe of the North Country, the wall of pines.

Glancing through Crisfield Johnson's 1878 *History of Washington County* some time later, I came across another Orson Kingsley. This one was born in 1807 in Fort Ann. In 1878, he was listed as a "retired farmer" in Comstock. His father, Supply Kingsley, had fought in the War of 1812. His grandfather Coomer Mason had come over to Fort Ann from Vermont in 1787.

IV

That winter I did not go up to experience the snowmobiling on Lake Champlain. In fact, I stopped going up to Route 22 altogether. A small crisis—the contractor in charge of renovating our apartment turned out to have wasted the money we had given him and the subcontractors had walked off the job—took up all my time, and the Route 22 idea looked as if it might recede into another of those unfinished projects collecting dust in a file cabinet in my mother-in-law's attic. Without a refrigerator or stove, my children starting school and my wife a part-time job teaching high school, I managed to send off an application to the Millay Colony and then turned my attention to family matters. My wife had bought a puppy that summer, a highly energetic Brittany spaniel. I started jogging around the park with the dog every morning, trying to work off my fury at the contractor. In a way, the jogging became a sort of substitute for Route 22.

I grew a beard. Angry that I had allowed the contractor to mishandle the job and throw away our money, I informed him that I would keep growing the beard until he had installed a sink and a mirror at which I could shave. I became the contractor, the contractor my frightened laborer. My children stared in horror as I had fits in front of the crouching contractor and yelled at Turkish marble workers for tracking limestone dust through the hallways. I forgot about Route 22, forgot about my wife and the book club, and thought only about finishing the renovation. My son photographed me one morning as I stomped around making his lunch for school.

One day in the middle of all this I received a letter from Daphne Kingsley. She wrote from Humboldt State University in northern California, where she was taking classes for a semester and visiting her sister. She wanted to know how my project was going, if I had any further questions about Whitehall, and if I could send her some of the pictures I had taken of her along her road. "I haven't found a good road to walk down, that gives me that sense of peace, out here," she wrote. The freshness and enthusiasm of her letter, her interest in my project, and her half-concealed curiosity about the pictures reminded me of the unfinished "experiment" that I had put aside to focus on my more immediate problems. I had managed to print some of the pictures but had not bothered to send them to the address in Whitehall that Daphne had given me. I FedExed them to her in California the next day.

We began corresponding by e-mail. She told me about her life and I told her about mine. She didn't have regular access to a computer and her e-mails were not frequent, but they persisted through the fall and winter. It was not the frequency of her e-mails that mattered anyway, but the knowledge of them, which seemed to open up a new sense of space in my life. All I had to do, when washing the dishes or out running the dog around, was to remind myself of Daphne and my unfinished project, and that sense of space would reappear.

In February, I received a jury summons requiring me to show up at the New York State Supreme Court building at 111 Centre Street in downtown Manhattan in two Wednesdays. Not a little distressed at having to let go of everything I was doing and show up in downtown Manhattan for an unspecified period of time, I dropped my son off early at school the morning I was scheduled to go and rode the IRT down to the Brooklyn Bridge stop. Walking north along Park Row, beside City Hall Park, I realized that I was walking along Route 22. It was the bleak time of year when bitter winds come hurtling in off the East River, swirling dust in circles and flattening stray papers against NO PARKING signs. Mayor Giuliani had recently fenced off City Hall Park and the police had erected barricades around it—the mayor to renovate the park, the police to prevent terrorists from driving up and bombing City Hall. Passage around the park and through the barricades proved difficult and lonely. I wished I was upstate again, away from all this anxiety and fear.

"You've got a camera in your briefcase," observed one of the cops standing by the X-ray machine at 111 Centre Street. "What're you, a reporter?" "I like to take pictures," I confessed. The officers conferred among themselves. "All right, we'll let you take it in. But no pictures of anything inside the building." "Or anybody," added another cop. I rode the elevator to the jury room and watched a movie in which judges, lawyers, and former jurors, all dressed up for the camera, discussed the special feeling one got in one's heart from participating in a system of trial by jury. Tears came to my eyes, during the moments in the film set aside for such emotions, at the prospect of a criminal justice system that would operate according to other rules. Afterward, I carried my bag into a room set aside for people with laptop computers, took my shoes off, and put my feet up in a carrel. I was beginning to feel better now that I could conceive of all this as taking place along Route 22. I opened a book.

As it happened, I was reading Samuel Eliot Morison's biography of Samuel de Champlain. Obsessed with Champlain for years, Morison had sailed his sloop into many of the harbors in Canada that Champlain had mapped 350 years before, using Champlain's charts. Many of those old charts, Morison had discovered, were still accurate. It seemed to me that Morison must have gotten a new kind of knowledge of Champlain by navigating, in a sense, through the dead man's eyes. Unfortunately, my reading was soon interrupted by the sound of my name in a loudspeaker. I followed a group of jurors down two flights of stairs to a courtroom and squeezed into a corner of the jury box.

A man, the side of whose face I could see at the defense table, was accused of having held up a Gristedes supermarket on Third Avenue. It was expected that the presenting of evidence would take about two weeks, give or take a day or two, with summations the following week. The whole process, the judge said, would probably take about two and a half weeks. If there was anyone in the room who thought he or she would have a problem being here for that long, would he or she now please raise his or her hand and come forward and explain?

 For a moment I considered not raising my hand. Not only was the courtroom in which I was sitting on Route 22, but so was the Gristedes supermarket. Moreover, if the defendant was found guilty and sent upstate, he might very well be sent to the Great Meadows Correctional Facility in Comstock. In other words, his crime, conviction, and punishment would all have taken place on Route 22. This was not a supposition with meaning for anyone but myself, yet I could not help being impressed at how, from one of the densest urban settings in the world, the defendant could be transported, at a word from the jury, to a nearly forgotten township upstate, to an enclosure within an enclosure within an enclosure within fields upon fields of crickets, grasshoppers, purple loosestrife, and Queen Anne's lace.

I did raise my hand, however, and when my turn came I gave the judge a story that didn't hold water and that he didn't believe for a second—all about Samuel de Champlain and Route 22—but which was so ridiculous, and came from such an unexpected angle, that he dismissed me anyway, out of humor I suppose, and I trudged back upstairs to the jury room, feeling guilty about the cavalier way I had just treated the fate of the accused but at the same time relieved to be alone again with Champlain.

The more I read about the French explorer, who had named the sixth largest lake in North America for himself, the more fascinated I became by the mysteries of his character. Himself an artist, whose extraordinarily accurate and personally illustrated maps guided travelers through new lands for generations after his death, he left behind no picture of himself. He recorded with care the soundings of channels, the heights of bluffs, the shapes of islands, and the positions of stars yet bequeathed us no map to the contours of his own face. Despite the nearly complete lack of information on what Champlain looked like, the people of Plattsburgh, New York, erected a life-size statue of him, atop a granite pedestal, in 1911 in honor of the three hundredth anniversary of his discovery of the lake. There is no evidence that he ever set foot in what is now Plattsburgh, nor that he bore any resemblance to the fellow on the pedestal, but the image of him remains. I had not yet visited Plattsburgh, one of the biggest towns on the section of Route 22 along Lake Champlain, but I remembered that during the years before World War I my grandfather had spent time at the reserve officers' training camps there. It seemed to me that my life would be incomplete unless I went there myself.

During the lunch hour, I wandered the streets of lower Manhattan, looking at the buildings that were also, in their way, part of Route 22. Mostly I looked at the well-known ones—City Hall, the Municipal and Woolworth buildings—but at one point I found myself gazing at an unimportant one, a nineteenth-century building standing by itself in a block that was in the process of being torn down. Around it clustered shacklike structures containing the temporary quarters of jewelry shops, film developing emporiums, fried chicken and souvlaki places; behind ranged the much higher windows of the New York Life Insurance Company Building, a landmark, partly designed by Stanford White. The building behind would remain safe from the wrecking ball but the one in front, well proportioned as it was, with wide many-paned windows and a facade of granite brought in from Maine or someplace, would soon be gone. How long had it taken to build? Who had built it? Who had worked there? What ugly, cheap, profitable structure would replace it? Who had decided that it was no longer of value?

The small building reminded me of the D&H repair shed in Whitehall, and I climbed onto a bench and started to take a picture of it. Immediately a cop appeared. Three others followed. A fifth rounded a corner. "Hey!" the first said. "This is a federal plaza. No photography allowed." "Excuse me?" "There are undercover agents in this plaza," he explained. "They don't want to be photographed." "Why?" "Terrorists," he said. I remembered the World Trade Center bombing of 1993 and assured him that I was photographing only to make a record of an old building about to be demolished for legitimate purposes. "It doesn't matter. This is Federal Plaza. You are not supposed to be here with a camera." As I walked away, I noticed only one other person in the plaza of the Jacob Javits Federal Office Building on that cold day. Hunched over in an army coat, the old man with the Santa Claus beard seemed intent on avoiding my eye.

I never got on a case. On Friday afternoon the jury room clerk freed me, and I rode the elevator to the top of the World Trade Center. I had not been to the top of that building in many years and was surprised by all the helicopters buzzing about. Who rode those helicopters? Leaning on the rail, I looked out over the harbor, at the flag flapping on Bedloe's Island (its name changed to Liberty at the instigation of a public relations–minded senator), at the statue itself, given by France and dedicated in 1886; at the oil tanks and derricks of Bayonne; and, behind, arching up like a Ferris wheel, the Bayonne Bridge, completed in 1931, the longest steel-arch bridge in the world.

I remembered that the same year (1609) in which Champlain had paddled down a lake far to the north and named it for himself, Henry Hudson had sailed into this harbor and up the river that also came to bear his name. Eventually the routes taken by the two explorers came to be seen as connected and to form a water highway between Manhattan and Montreal. The apex of this highway, the meeting point for the two routes from the south and the north, was the stream that spilled out of Lake George into Lake Champlain, called "La Chute." At other times I might have enjoyed knowing these things, which I had learned through my research on Route 22, but tonight they only made me feel bad. I remembered seeing and crossing La Chute on my visit to Ticonderoga but I had never been to Montreal nor even to Plattsburgh. I kept thinking of Montreal and the northern section of Route 22 as evening came on and the helicopters buzzed back and forth. Then I stepped back into the elevator and descended to my regular life.

That night, I told my wife that I needed to take one last trip up Route 22, to Plattsburgh, and on up the final stretch of road to Montreal. My grandfather had trained at the officers' training camps in Plattsburgh before World War I, I reminded her, and I had always wanted to go there. I had started this project and wanted to complete it, and I knew how easy it would be to let it slide. If I did not finish it now I never would. My wife stared at me for a while without saying anything, and I thought that I must have upset her by asking once again for time by myself without her or the children—or that I had tapped into some deeper concern. Our lives were so full, in those days, of deeper concerns. "That could probably work out," she said after a while, "when the children and I are off during the spring vacation. But you'll have to take the dog." How she could be so clear, not only about the joint timing of the vacations but also about the question of the dog, was one of those examples of foresight in my wife that always astonished and somewhat alarmed me.

V

I e-mailed Daphne Kingsley and told her that I was coming to Plattsburgh and she offered to take me on a hike in the Adirondacks. In her e-mails she had talked a lot about the Adirondacks and the fun she and her friends had camping there, and I had told her about my experiences there years before. As always is the case with such trips, a great deal of planning failed to prepare me for my actual moment of departure, and the day before I left I was out buying film when Daphne called me at home. "So," said my wife when I got back to the apartment, "who is Daphne?" "Somebody I've been interviewing about Route 22." "Right." "I took pictures of her in Whitehall and she goes to college in Plattsburgh and offered to show me around." "Right." Nothing I could say would convince her that I wasn't having an affair with this girl and when I left the next morning she gave me a wry glance before turning back to her computer, and I almost didn't go.

I drove straight up the New York Thruway, pulling in to rest stops to walk the dog on the brown grass behind throbbing trucks along the margin of the road. At Exit 32 I turned east through collapsing farmhouses and trailers behind a school bus from which children tumbled toward dogs leaping and barking in driveways. I turned north again at Essex, passed through the Adirondack foothill towns of Willsboro, Keeseville, and Peru, and late in the day came down to a tableland of just-plowed fields and the twisted, reddish branches of apples. On a tarmac stretching off through empty, military-green hangars sat a lone 747. The 747 had "Air Dabia" on its side. Not having heard of such an airline, I wondered if it was a spy plane. The Plattsburgh air force base had been decommissioned in 1993 and officially closed in 1995 but the government might still keep planes there, I reasoned.

 Plattsburgh's relationship with the military goes way back. About twenty miles south of the Canadian border on Lake Champlain, Plattsburgh replaced Ticonderoga, during the nineteenth century, as a point of defense against invaders from the north. It was here, in 1814, that the combined forces of Commodore Thomas MacDonough, on the water off Cumberland Head, and General Alexander Macomb, on the breastworks in the middle of town, turned back a large British attack and helped put an end to the War of 1812. The Plattsburgh "barracks," as the military base along Lake Champlain was first known, has had some level of military presence ever since. During the first half of the twentieth century, the Twenty-sixth "Iron First" Infantry division of the U.S. Army was stationed here. For a brief period during the 1940s it was a naval training facility, and from 1955 to 1995 it was the home of the 380th Bombardment Wing of the U.S. Air Force.

I found myself in a yellowish brownish room with two queen-size beds overlooking the parking lot of a United Parcel Service distribution center. I had chosen the Econo Lodge because it was the only place that took dogs. I half expected to find traces of my grandfather among the gray piles of snow that lingered along the sides of the road and at the edges of parking lots. Among the stories he had told was one about celebrating his twenty-first birthday at the Champlain Hotel in Plattsburgh, and another about how he had served as a sort of unofficial spy and double agent between his father and older brother during field maneuvers the first year he was here, when he was technically too young for the training camps. (The camps continued to train young men as reserve officers until 1939, just before the United States entered World War II. The Champlain Hotel is now part of Clinton Community College.) The remoteness of Plattsburgh on the northwest shore of Lake Champlain, the plainness of its name, the portrait Daphne Kingsley had painted of it as a place of culture very different from Whitehall, and the fact that Daphne herself was here made the town seem as if it must be something more than what it appeared.

The next morning, I took the dog for a walk in the field behind the hotel and sampled the free breakfast in the lounge: bagels and toaster waffles on Styrofoam plates. On a TV angled down from a corner, a man was telling an interviewer about a book he had just written on the subject of menopause. The experience of his wife going through this passage of life had taught him what a difficult and noble thing it is for a woman. He'd had no idea how bad it would be for her, and he couldn't say he'd been particularly good about it himself, so he'd decided to write a book about it to educate other men. Except for a truck driver in a cowboy hat, nobody else in the room was paying any attention to the menopause man. His self-confident yet somehow meaningless words made me feel anxious and I was glad to return to my room, where Daphne met me a few minutes later. She strode through the doorway and gave me a hug. I couldn't believe she was there. I told her about the menopause man and she laughed and we talked about the different mountains. I had spoken to almost nobody since leaving New York City the day before and I became very talkative and thought her suggestion that we hike up Hurricane Mountain was great. We stopped at a ski shop to rent snowshoes and headed south.

The snowshoes turned out to be essential. The seasonal road in to the trailhead was snowed under and we had to park three miles farther back than Daphne's guidebook indicated. But it was sunny with puffy clouds and warm, and we started off anyway, past stands of balsam and birch, each tree type in its own zone of sun or shade, separated from the others by a distinct line of change, junior balsams clustering back and farther back among poles of parent pines. Wind-stunted junipers on a rocky cliff face looked, from below, like pagodas. No bird sounds except chickadees, and all around us drops of water dripping from branches, melting snow falling to snow. We talked about the woods and the feeling that something is out there and the knowledge that nothing is. Daphne wore hiking boots, brown wool pants, white cotton shirt, blue down vest. I felt as if she were a long-lost cousin or sister, understood exactly what she meant about how in her younger years she had believed in wood spirits. Happiness came from the fragrant balsam needles she kept crushing in her fingers and from the half-moon she discovered peeking down on us through the high tops of those same balsams when the trail narrowed and we passed through a V of fallen birches.

We stopped for lunch, sat on our snowshoes, ate sandwiches and apples. The dog dashed in quivering, snow-covered; drank water from my cup; dashed off again. A vegetarian, Daphne ate peanut butter and jelly on whole wheat while I tore into my heavy ham and swiss. Chunks of snow dropped from balsam boughs. We packed up and started off again, speaking about the most ridiculous things. I gave her plot summaries of *Madame Bovary*, *Anna Karenina*, *Lolita*, *Crime and Punishment*. Told her stories of my sister and her first and second husbands, of my aunt and uncle in Idaho, of my year off from college, of snow camping in the Adirondacks with my college roommate, of the Opalescent River: all features of my life, I realized, when I had been Daphne's age. Daphne told me about her parents, her twin sister, her sister's boyfriend. Her job this semester posing nude for undergraduate drawing classes. Her goal to have an organic farm and to take some years off from college and travel around the country to learn more about organic farming. As we were talking, the sun went down. We stopped. The trees swirled. Cold crept in the woods. Silence fell like rain. We looked at the map and at the sky and at each other. We could keep going to the top and risk getting caught after dark in the cold without a tent. Or we could turn around and go back. An image of myself at Daphne's age, exactly half my own at the moment, came to me and I knew that if I were as I had been I would unquestioningly have pursued Daphne with every strategy at my disposal. As it was, we turned our snowshoes around and talked about other things as we wound our way back down through the silent woods to Route 22.

Thumbing through my shoe box of cassettes on the way back, Daphne pulled out one by Bob Dylan called *Desire*. She had heard this album for the first time, she said, just two days before, in the drawing class in which she posed for the art students. It really makes a difference when you are posing, she said, to listen to music. She had especially liked the first song on side one, called "Hurricane." The summer before, she and some friends had driven to Lake Placid to hear Dylan perform with Natalie Merchant. For an encore, Dylan had sung, of course, "Girl from the North Country." As I absorbed these coincidences, which seemed to correspond to the other connections between us, we passed through a stretch of almost comically ancient motels, long, low, pastel-colored units with ornate white garden furniture, tiny swimming pools, and signs whose neon had been flashing for half a century.

"You should stop here," Daphne said, pointing to a deserted parking lot. "The Ausable Chasm." It was closed today—March, not a time when a lot of tourists passed through Keeseville, New York. Gates barred our way, the ticket house was closed. We climbed a fence, nosed along a ledge, strode across a brown wet lawn. Looked down. Daphne said something but I couldn't hear her over the roar of the water. She came closer, repeated what she had said. Farther down, she was telling me, you could hike along the gorge. The pale cold light off the ice, off the mist, off the plummeting water glowed in her pale warm face and I raised my camera to take her picture but she put her hand on my arm to stop me. She couldn't explain it, she shouted over the water. She had no problem posing nude for the undergraduate drawing class, but she did not like having her picture taken these days. I photographed the waterfall instead. Later, in the parking lot of my hotel, she smiled a quick good-bye and hurried off to her small pickup truck, which she had left there.

The next morning I drove to Montreal. It felt funny to be setting out alone after spending the entire previous day with Daphne. I saw that my fears were now coming true: I was becoming sidetracked from the road. Remembering Daphne's choice of music the day before, I stopped at the Champlain Centre North mall on my way out of town to see if I could find any new Bob Dylan cassettes. The mall was open but the parking lot deserted. I found a music shop but the only cassette that I did not already own was *Bringing It All Back Home*. I drove out of the parking lot listening to "Gates of Eden" but the hard minor keys and plaintive harmonica riffs only seemed to add to my loneliness. I began thinking about Samuel de Champlain and how much he had accomplished by the time he reached my age. Driven by a lust for discovery and an almost maniacal devotion to the land he called "New France," Champlain had come back and back again to sail and paddle and walk up rivers where no European had set foot, through the smoke and stares of tribes that knew neither gunpowder nor steel. He was thirty-nine when he accepted the invitation of some Algonquins to join them on a war party down a long lake that led to a river that led to another lake that led to another river that led to the sea—and discovered Lake Champlain. He was exactly my age when, a year later, on one of his trips back to France, he married a twelve-year-old. As part of the marriage pact, he promised the girl's parents not to consummate the marriage until she turned fourteen. Despite frequent journeys back to New France, he did not bring Helene to Quebec until 1620, when she was twenty-two. He lived with her there until his death in 1635.

As I approached the Canadian border, shafts of sun broke through the clouds to race along the road and out across the stunted tops of the trees. Daphne had told me that the consistently damaged look of the trees up here — not just the black locusts, but maples with sap buckets beneath them, oaks with mailboxes nailed to them, birches arching this way and that back into swamps — was the result not of a particular local weather pattern that kept the trees in a permanent state of deformity, but of an ice storm the previous winter that had locked the region under a brutal spell for a week, closing bridges, downing power lines, leaving thousands without electricity, passing across the flatlands around Plattsburgh like a hand, brushing off the tops and loose branches of the trees, giving the land a look of a place devastated by war. I remembered reading about this storm in the *Times*. That same week, New York City had experienced an unusual heat wave. In our shirtsleeves my wife and I had strolled to the Degas exhibit at the Met and spent a couple of hours there, lost among the pictures. "The masters," I had recorded in my notebook, quoting Degas, "must be copied over and over again, and it is only after proving yourself a good copyist that you should reasonably be permitted to draw a radish from nature." On the way home we'd talked nonstop about the show and about how difficult it is to render accurately and faithfully even the simplest of things that one sees.

At the border, Route 22 officially comes to an end. But the road itself continues, without a break, past a sawmill to the town of Hemmingford. It is now called Route 219, the road signs are bilingual, the prices at gas stations are in Canadian dollars, and gas is sold in liters, but the pavement is unbroken, uncoiling ahead to Montreal and behind several hundred miles to Manhattan. After Hemmingford, a region of vast farms opens up. Allée after allée of poplars leads off a straight flat road across a straight flat plain softened by wheat fields. Whatever Jacques Cartier was looking for when, in 1535, he first sailed up the river later called the St. Lawrence (a route to Asia, power over England, converts, beaver), he left behind a language—and, along with the language, evidently, views on landscaping. Cartier followed some native people to the top of a hill beside the St. Lawrence, erected a cross there, and named the place Mont Reale. Later, Champlain sailed up and down the St. Lawrence, recording soundings and channels, depositing names, using it as a base for his further travels. I was curious to see where my own travels would land me in Montreal but realized that in my focus on Plattsburgh I had read almost nothing about this ultimate destination. Montreal would present itself to me as it was—as, I reasoned, so many places had to Champlain.

I crossed the long bridge over the St. Lawrence, looped over highways and under underpasses to the Vieille Ville and parked in front of the Chappelle Notre-Dame-de-Bon-Secours. I noted the Virgin Mary stretching her arms out to sailors coming in from the sea, but feeling vaguely impatient for something I could not identify, I did not go in. I put the dog on her leash and wandered up a tourist promenade called the Place Jacques Cartier where a puppeteer, a sword swallower, and the maître d's of numerous restaurants competed for my wallet. Skirting vast puddles from melting piles of snow, I had the feeling that everything I was seeing was provisional, to be made real only later, when I came back another time and stayed longer. This made me sad: I did not know that there would be another time. Passing yet another French restaurant with its yellow walls, white tablecloths, and wine bottles in the window, I regretted not having left my dog in the car. It would have been nice either to have convinced Daphne to ride up with me or somehow arranged to come with my wife. Instead, I tied the dog to a lamppost outside the reconditioned Public Market and wandered through a mini-mall of gift shops and coffee bars until I found a ham and cheese on a baguette and some French coffee for the road. I came out a different door from the one I had entered and found the dog barking frantically at the door I had previously gone through. I brought her back to the car and gave her a drink of water. Another network of highways drew us out of town and back over the river.

Back in Plattsburgh, Nancy Duniho, the owner of the Corner-Stone Bookshop, sold me a copy of *The Plattsburgh Manual: A Handbook for Federal Training Camps*, by Lieutenant O. O. Ellis and Lieutenant E. B. Garey. It had been published in 1917, soon after my grandfather came up here to train, and abounded with such sentences as "the average man attending a federal training camp wants to know as much as possible about the art and science of war." The Corner-Stone Bookshop would be celebrating its twenty-fifth anniversary in 2000, and I took some commemorative pictures of Nancy Duniho. I had already put away my camera when sun pierced the window from over the top of the pool hall across the street, flooding the fluorescent dust-filled space with real light, like an arm from outside reaching in and turning everything around. By the time I had my camera out, however, the sun was gone. Still somewhat numb from my failed visit to Montreal, I said good-bye to Ms. Duniho and went out into the streets of Plattsburgh. A proper traveler, I thought, would be more aggressive than I, would know what he wanted and go for it. Whereas I, passive, lacking proper hierarchies, never knew what I wanted until it appeared before me. It seemed quite clear, for example—since I had done nothing to make it otherwise—that the purchase of *The Plattsburgh Manual* would be the closest I would come to the Plattsburgh base, the town's military past, and my grandfather.

According to Allan S. Everest, whose *Briefly Told: Plattsburgh, New York, 1784–1984* I had also bought at Nancy Duniho's shop, the first European to settle in the place we now call Plattsburgh was Charles de Fredenburg, a British army captain who had distinguished himself during the French and Indian Wars. He was granted 30,000 acres along the Saranac River in 1769, only to lose it during the American Revolution. In 1784, Judge Zephaniah Platt of Poughkeepsie and a group of settlers were granted roughly the same 30,000 acres along the Saranac by the new government at Albany, and the town officially began. Originating in a series of lakes high in the Adirondacks, the Saranac gives present-day Plattsburgh a feeling of impermanance, as if it existed not so much as a home but as a stopping place on the way to somewhere else. This feeling is compounded by the railroad tracks that slice through the village on the east side and the Northway that passes through on the west, and by the Georgia Pacific paper plant that, even as its banner welcomes you to town, rapidly produces objects bound for places far away. Motorboats appear on the Saranac and disappear into the fog of Lake Champlain. Canoes descend from the mountains to unload weekend adventurers. With its eagle poised at the top, the monument commemorating MacDonough's victory stands like a sentry at the mouth of the river. In Plattsburgh, life continues much as it has. Some boys asked me to photograph them in front of their hangout spot. They posed; I shot the picture and moved on.

That night, I figured I would check out the nightlife of Plattsburgh and I went down to a place called JC's. The club was packed with people white-haired and balding, from my age up through the sixties, who roared with laughter and clapped their hands and got up occasionally to dance to music played by a bunch of cynical and experienced musicians, also about my age, who were equally comfortable with David Bowie and Bob Marley. At one point the lead singer pointed at me standing in the back with my camera. "Who's that guy over there?" he asked into the microphone. "What's he got on his shoulder, a saxophone?" When I held up my camera he dismissed me with a wave of his hand. "You don't have to reveal yourself." A blonde at a nearby table shook her head at me and smiled as if in disbelief. She seemed to want to say something to me and I went over. "What the hell are you doing standing over there in the corner by yourself?" I showed her my camera and said something about Route 22 and she shook her head, still smiling at the joke I seemed to represent for her, and I went back to my corner and busied myself with the camera and then a few minutes later I slunk out.

In the morning I loitered around the Champlain monument watching my dog try to flush families of hissing geese. A fund-raising campaign had created a system whereby townspeople could purchase bricks with their names and special messages written on them that would be placed around the base of the monument. As I walked across these small inscriptions, I felt as if I were trodding on graves. They dated, some of them, from the 1970s, when the campaign to keep up the monument had perhaps begun, and made the passage of time seem even more painful and grand by gathering so permanently, in one place, so much ephemeral information. It was strange to think that the mom celebrated as the world's best in 1979 would be twenty years older now and for all I knew already in the grave. Would her children still feel the same way about her? Would she still feel the same way about herself?

Brenna Miller and Amanda Darrah, both thirteen, gave me a tour of the Kent-Delord House. Plattsburgh's most famous historic structure contained much interesting stuff, including the writing desk of a former inhabitant who had invented a patent medicine and a chest left behind by British officers forced to flee after their repulsion from Plattsburgh in 1814. In one of the rooms the girls pointed out a gigantic, faded-looking wreath in a frame. They asked if I was familiar with mourning wreaths and, when I confessed that I was not, they asked if I could guess what they were made of. "Grass," I told them at first; but then, after inspecting the horseshoe-shaped construction more closely, and noticing the variety of shades and the intricacy of the weaving, I changed my response to "silk." "Mourning wreaths are made of human hair," Brenna said. "It's a different way of remembering a loved one." I confessed that I did not see how a single dead person could have produced so much hair in such strikingly different colors. "Oh, the wreaths included more than one person," Amanda said. "Yes," Brenna said, "they were usually kept by a family. When someone died, the new person's hairs would be added. They kept it in a special place and only brought it out on special occasions." "Like when someone died," Amanda said. I stood there looking at the wreath for quite a while, re-creating city councilmen, bridge-playing senior citizens, a young boy on a sled. Death seemed a strange kind of victory to celebrate with a wreath. After a while I began to feel badly about the two girls, who, very much alive, were standing off to one side watching me, and I followed them into the next room.

On my last night in Plattsburgh, I called Daphne and asked if she would like to go to a movie. To my surprise, she said yes. We met at the Strand and sat halfway back and watched *Life Is Beautiful*. I had suggested it because I liked the title and somebody had told me that it was good, but it turned out to be almost too serious and we were a bit stunned when we came out. *Shakespeare in Love* was also playing and I wished we'd gone to see that instead, but Daphne had already seen it. We went out for dessert to a place called Irises and our moods lifted somewhat over plates of Belgian triple chocolate truffle cake. Daphne asked if, in my wanderings about Plattsburgh, I had happened to notice how the French explorer on the Champlain Monument is basically standing on the head of the Native American warrior? I said that I had not, but was glad she had pointed it out. Afterward, I drove her home to the apartment that she shared with her sister on Route 22 just south of Plattsburgh. She asked if I would like to meet her sister and we went upstairs, but her sister wasn't home. Daphne showed me instead an album of photographs of herself and her siblings and cousins when they had been younger, back in the days when they had jumped into the stream and spray-painted their names on the bridge. Then I said I better go. We stood there looking at each other for a moment. "I have a hard time saying good-byes," Daphne said kindly, noticing my awkwardness at leaving not only her but Plattsburgh and, for all I knew, Route 22 itself behind. We said them, however, and I walked out the door and down the stairs and drove across town to the Econo Lodge, then walked down the corridor of identical doors to the one where my dog waited. I put her on her leash and, still hearing those last words of Daphne's, brought the dog out into the field behind the hotel and walked her around a few times in the cold and the moonlight before bringing her back inside. I had not expected that it would be so hard to say good-bye.

VI

I guess I thought that that would be my last trip up Route 22. I had visited every stretch of the road from Manhattan to Montreal and had proved my mother's assertion, so many years ago, about the outcome of the road in Canada to be essentially correct. I had met some interesting people and taken some interesting pictures and gotten to know a little better a region that until then had existed for me only as a myth. But saying good-bye turned out to be impossible. Soon after I returned from Plattsburgh, I received a call from the Millay Colony accepting me for a residency during the month of August. I had nearly forgotten that I had applied, and I almost turned them down. My wife's uncle, the one who owned the Grandma Moses painting, had recently died after a short illness, and, in one of those paradoxical moves that seem to make sense when you are losing someone you love, we had conceived a child. The baby was not due until the following January, but I did not feel it would be fair to take off again by myself. A new kind of alliance had sprung up between my wife and me since my return from Plattsburgh. We had both let go of our marriage somewhat, yet it had not gone away. Her pregnancy, which would end up precluding or at least highly restricting book clubs and poetry readings for her and wanderings in the North Country for me, seemed a confirmation of something new between us, or at least in ourselves. I did not want to wreck that. Yet full of the hopefulness that comes over one after sacrificing oneself gladly to fate, my wife said she thought I might as well go to the Millay Colony now while I had the chance.

Thus it was that, a few months later, I found myself alone in the woods near Austerlitz, New York, with a composer, a short story writer, a collage artist, a novelist, and a painter. I felt surprised and elated to be there with these serious artists and to be able to devote myself, for a whole month, to this project whose very existence I had so often doubted. According to Elizabeth Barnett, Edna St. Vincent Millay's literary executor (who showed up one evening and gave us a rare, impromptu tour of Millay's old house), Millay had bought the property in 1925, entirely on her earnings as a poet. She and her husband, Eugen Boissevain, had lived there until Boissevain's death in 1949 and hers in 1950. After Millay died her sister Norma Millay Ellis and brother-in-law Charles Ellis came to live permanently on the 635-acre property, known as Steepletop. In 1973, the Ellises converted a barn and the loft of a garage into studios and bedrooms where, for a month, men and women could work and think among the trees and fields of the Berkshires without distractions. A new building was added in 1997, but otherwise things were much the same for us as they had been when the Ellises had opened the colony twenty-six years before. One night I photographed our group at the swimming pool behind Millay's house. According to Ms. Barnett, Millay and Boissevain and their friends had liked to photograph one another in that same spot, often without clothes.

I was given a bedroom and studio just down the hall from the darkroom in the "new" building, and there I fell into a routine that, I suspect, if I had remained single—and certainly if I had spent more time at artists' colonies—might very well have become the routine of my life. I awoke at ten, fixed myself coffee and toast in the kitchen, and read and took notes in bed until noon. After lunch I drove to the Shaker colony in New Lebanon, to Hoosick Falls, to the Map Room at the state archives in Albany, or elsewhere along Route 22, and did research, took pictures, and explored until seven, when dinner was served. After dinner I went into the darkroom, developed my negatives from the day, and made contact sheets. Usually, while the negatives were drying, I also made prints, small ones to keep in my notebook. I had not had access to a darkroom in years and finding myself able to develop and print the pictures I had taken just a few hours before was intoxicating. I got into bed long after midnight and read until my mind slowed and I fell asleep. Mostly I read treatises by local historians about places and events along Route 22, but these kept suggesting more general works, and I became engrossed in Francis Parkman's *Montcalm and Wolfe* and *Pioneers of France in the New World*. Sometimes, in the evening after supper, I walked around the property with the other artists, exploring the fields and trails that Millay and Boissevain had cleared.

When Elizabeth Barnett opened the Millay house for us, repairs were under way and we were lucky to be allowed inside. In the living room—the "withdrawing room," Millay sometimes called it—we found Millay's two grand pianos, her Remington typewriter, and a bust of Sappho. Paintings by her brother-in-law Charles Ellis covered the walls. In the library upstairs, a down cushion still bore, mysteriously, the imprint of the last person who had sat in it. In Millay's bedroom, a pair of riding boots, size four and a half, reminded us of how small the poet's feet had been. Elizabeth Barnett showed us silk gowns gone translucent and brittle with age, a peacock-feather hat, and an empty bottle of wine that Millay had bought for the poet Elinor Wylie on her birthday. (Wylie died before she could drink it, so Millay finished the bottle with Wylie's husband instead.)

Out back, Ms. Barnett showed us the small cabin where Millay had done her writing. I looked for clues about the poet, why she had moved up here from the city, what had kept her going, and why she had written the way she had, but the cabin was bare, the grass around it waving in the wind. I found myself thinking of others who had pursued, or were still pursuing, projects along Route 22: Bijan Mahoodi, Grandma Moses and her great-grandson Will, Olivia Sumerlin with her ballet school, Carol Greenough and the people renovating the Skene Manor in Whitehall. A lighthearted feeling came over me, similar to what I had experienced when I received Daphne Kingsley's first letter, to remember all these people devoting themselves to their particular kinds of work along this upstate road. It made me think of getting back to my own work. Later, to my wife, I would call this hopeful state of mind the "Route 22 feeling."

One evening I walked down into the woods to the spot where Millay and Boissevain are buried, side by side, under a fieldstone that the poet found on the property. Not far away, in the same clearing, lies Millay's mother, Cora, who died in 1931. It was dusk, and I kept catching glimpses, on side paths out into fields, of places that seemed to have been transformed into other places by the fast-fading light. Standing by the lichen-encrusted stone, surrounded by miscellaneous plants in the darkening woods, I tried to think of a line by Millay that would be appropriate to the moment. Millay was one of my wife's favorite poets, and I was well aware of how many subtle and dark lines, especially ones having to do with death and the woods, were to be found in her work. But all that would come to mind was something entirely inappropriate, a cliché almost, the sort of thing that everyone remembered: "We were very tired, we were very merry—/We had gone back and forth all night on the ferry." I tried to push these lines away, but the harder I tried not to think of them the more they repeated themselves.

As I stood there, a car passed quite close below me. A moment later, a second car passed. Headlights flickered across the trees. Curious about these vehicles, which seemed to come from nowhere, I walked about two hundred feet down into the woods and found myself on Route 22. When Millay had chosen that place to bury her mother and, years later, her husband, it had been deep in the woods, far from anyone. Since then, Route 22 must have been moved. As I climbed back up to my camera, I thought about how few people driving along that lonely stretch of road were probably aware that just up the bank and through the trees was the grave of a famous American poet.

Despite the inner fascinations of the Millay Colony and the luxury of unhampered time for work, we regularly went off on side excursions. A favorite place to go was the Shaker colony near Route 22 in New Lebanon. One day some of my fellow artists came back from New Lebanon with some oddly shaped, purplish tomatoes. They cut up the tomatoes and passed them around and we ate them like fruit. Tomatoes in fact are fruit, but none of us had ever tasted any as sweet and juicy as these. A few days later, going to the Shaker colony myself, I stopped at the Wild Harvest fruit stand to buy some more and to meet Riccardo DeLuca, the man who had grown them. As it turned out, Riccardo was not there but his daughter, Kristen, was. Kristen told me that she had just graduated from high school and was working here for the summer before traveling west to live with her sister in Colorado. Her plan was to take a couple of years off before deciding about college and what to do with her life. Her family lived just over the state line in Pittsfield and had been in the restaurant business for generations, she said. Her grandmother had cooked for Frank Sinatra and her father was planning to open his own restaurant, also called Wild Harvest, just a couple of dozen yards away from the fruit stand. After taking some pictures of Kristen I felt almost silly picking out several of the small, irregular tomatoes from the box on the side of the stand closest to Route 22. I meant to bring them home for everyone to enjoy but after I tasted one in the parking lot of the Shaker colony something came over me and I ate the rest in a kind of frenzy, the juice dripping down my chin.

At the very end of his trip to America—the same one on which he visited Whitehall—Charles Dickens took one last steamboat ride up the Hudson to visit the headquarters of the American Shakers at Mount Lebanon. The visit was not a success. The whitewashed rooms of the hotel in the nearby town of New Lebanon reminded him of prison cells. The hospitality of the Shakers left even more to be desired. "We walked into a grim room," he wrote, "where several grim hats were hanging on grim pegs, and the time was grimly told by a grim clock, which uttered every tick with a kind of struggle, as if it broke the grim silence reluctantly, and under protest." Unbeknownst to Dickens, the Shakers, overrun with tourists, had recently published in the newspaper a rule forbidding visitors at their worship. Their refusal to bend this rule for him so incensed the English writer that, in his description of the event, he went off on a tirade against religions that make a virtue of celibacy. He and his wife managed to walk up and down the main street a few times, then took furious solace in a gift shop. A few days later they sailed for England.

"Do you want a tour, or do you want to look around on your own?" asked the girl behind the gift shop counter when I visited the first time. She had thick curly brown hair and green eyes. I asked how long the tour would be. "About an hour." "Who is the tour guide?" "We have volunteers," she said vaguely; and then, focusing, "actually, it's my mother." "I guess I'll have the tour." I paid and she opened an umbrella and disappeared into the rain. A few minutes later she came back with a line of perplexity on her brow. Her mom was surely somewhere, she said, but she couldn't find her. Probably I should just follow her upstairs. I suggested that perhaps she (the daughter) should give me the tour instead, but she said she really didn't know anything about the Shakers. Her mom was the expert; she just had a summer job in the gift shop.

 She led me up a wide wooden staircase in a building called the Washhouse (1854) and wandered off calling for her mother while I examined blowups of some grim-looking—*Dickensian*—ladies in white head scarves. After a while a brown-haired woman with glasses, a softer, slightly more frazzled version of the daughter (much more friendly-looking than the women in the photographs), appeared from a back staircase. "So you want a tour," she said. I said that I thought I probably did, but not if it was too much trouble. "Oh no!" she said. "It's not too much trouble at all. It's just that I've had three tours already and I'm about Shaker'd out!" As she spoke I noticed the daughter smiling at me over her mother's shoulder. She lifted her skirt and began carefully descending the stairs away from me. Long after I had lost sight of her—long after I had covered a page of my notebook with information from the mother—I seemed still to hear her clogs clacking across the wide floorboards below.

The "Shaking Quakers," as they were derisively called back in England for the strange movements they made during religious ceremonies, came to this continent, Jean O'Hara informed me, in 1774 under the leadership of Mother Ann Lee. They settled near Albany, and formally "opened" their ministry on May 19, 1780, a day known among the Shakers as "Dark Day" because an ominous smoke, caused by forest fires in Quebec, obscured the sun from upstate New York. Joseph Meacham, a former Baptist pastor, started the first official Shaker community here at Mount Lebanon in 1784, and Mount Lebanon soon became the center of a network of Shaker villages that came to include, at its height, about four thousand brothers, sisters, and elders in seventeen villages around the country. Now there were just seven Shakers left, all living at one community in Maine. "I suppose you want to know about their celibacy," Jean said, with a sudden sharp look; and when I confessed that this was certainly a quality of the Shakers that was of interest to outsiders—that even Charles Dickens had taken note of it—she laughed and said that most outsiders really didn't understand it, and that there were advantages to it that we would do well to understand in our own time.

"You have to remember their attitude toward machines," Jean said. "Unlike the Amish, the Shakers embraced machines, because labor-saving inventions gave them more time to worship God." This progressive attitude toward technology, Jeanne explained, helped the Shakers to come up with numerous tools and devices, many of which are still used today. For example, they created a revolving oven that could bake fifty pies at a time. It was here at Mount Lebanon, too, under the interested eye of the Shakers, who asked nothing in return but the price of a vacuum pan, that Gail Borden had developed the process to condense milk that made him one of the wealthiest men in the country. "And helped," I asked, "spur the growth of dairy farming along Route 22?" "Exactly," said Jean O'Hara, looking at me with new interest. "The Shakers didn't believe in patents. They thought it was fine for Gail Borden to take their invention down to Brewster and open a factory there." "Brewster's on Route 22," I observed. "I know," she said.

The aim of being a Shaker, Jean went on, was not to make money but to find ways to free yourself to do the things you should do, which were to work and worship God. "The women cut their hair because hair was considered a woman's pride," she explained. "In the same way, they followed these rules of celibacy to block out anything that stopped you from accomplishing what you wanted to do." The point was really quite positive, she said, though we have a hard time seeing it today. It was to achieve a certain kind of freedom. "Well," said I, "but I do see it." And suddenly, quite strongly, standing there thinking about my own experiences at the Millay Colony and elsewhere on Route 22, I did.

Celibacy, however, was never going to be my own route to accomplishment, and when, the following January, my wife gave birth to our third child, I rediscovered a freedom of a different kind: that of the (relatively) competent parent. What do you do with a new baby? Drive him across country, of course. At least that's what we did. That summer, the summer of 2000, we traded in our old car for a minivan and drove out west to visit my sister in Idaho. So successful was the trip that in the fall, on Columbus Day weekend, we got back in the car and drove to Montreal. I was still unhappy with my first visit and thought it might help to go back.

On our way up, we stopped at Essex, another place I felt I had not seen adequately. Like every town along Lake Champlain, Essex has a port, but unlike many of the others it also has a ferry. On an earlier visit I had bought, in a small gift shop behind the Essex Inn, Ralph Nading Hill's *Lake Champlain: Key to Liberty*, and in this authoritative book I had learned that ferries have crossed Lake Champlain between Essex and Charlotte, Vermont, since the 1700s. In the 1820s, flat-bottomed boats powered by horses operating treadmills replaced the original sailing scows. In 1837, owners introduced a steam ferry that ran continually until its eventual replacement by diesel. I was curious at least to see, if not ride, the Essex ferry, which I had managed to miss when I passed through before. At dawn I snuck out from our room at the Essex Inn, where my family was sleeping, and drove down to watch the first ferry of the day head out across Lake Champlain.

After a large and lengthy breakfast on our first morning in Montreal, my wife and I left the older two to watch television and took the baby out to see some museums. We saw, among other things, a show at the McCord Museum of Canadian History by the nineteenth-century Montreal photographer William Notman. Notman was famous for his composite photographs. Onto a painting of an outdoor scene or a photograph of a room he would paste dozens, sometimes hundreds of individual studio portraits of Montreal residents and then photograph the resulting collage to create a single group portrait that he would sell to everyone involved. It was a time-consuming and irritating process, involving assistants, careful lighting, maniacal control of perspective, and much touching up; but the results were eerily beautiful. They made me think about my own very different efforts along Route 22, and how I might arrange my own pictures into a book to create a portrait of a road.

 We all had lunch at one of the restaurants I had passed a year and a half before on the Place Jacques Cartier, and the children got to spend some time watching the puppeteer and the sword swallower and a mime who stood perfectly still until you put a dollar into her hat, when she moved both arms, once. As I stood there beside my wife, with the baby on my back, waiting for the motionless mime to move, it occurred to me that I was cheating somewhat, approaching Route 22 no longer as a separate path alongside my regular life, but as part of my life. But that was all right. Route 22 was my own affair, I decided, and I could handle it as I liked.

The next day we climbed Mount Royal. It was cold and cloudy, and we wore sweaters and jackets as we made our way up through the century-old park designed by Frederick Law Olmsted and came out under the cross commemorating the one that Jacques Cartier had erected 465 years before. Like all the other tourists, we went to the rail and gazed south over the modern buildings and across the St. Lawrence toward the Adirondacks. I thought of the road that wound its way farther south, down the Champlain and Harlem valleys to New York City, and of a description I had read by Francis Parkman in which he compared the view from Mount Royal in his time to what it would have been in Cartier's. In Parkman's day, "tower and dome and spire, congregated roofs, white sail and gliding steamer" had "animated the scene." In Cartier's, by contrast, Parkman imagined that "east, west, and south, the mantling forest was over all, and the broad blue ribbon of the great river glistened amid a realm of verdure . . . the vast hive of industry, the mighty battle-ground of later centuries, lay sunk in savage torpor, wrapped in illimitable woods."

 Now, of course, not only were the woods gone but the "congregated roofs" had been broken apart by high-rises and apartment towers, and the domes of churches had given way to those of sports complexes. Everything was speeded up, cleaned up, paved over, glazed. Yet, in my mind at least, all that Parkman had written of was still here, like those door handles in the trees at my grandparents' house. I moped around for a while, thinking such thoughts and taking pictures of the other tourists admiring the view. Bored with waiting for me to finish, my son helped some girls launch a foam rocket across the visitors' veranda.

On our way home to Manhattan, we stopped at Whitehall for lunch. The Lock 12 was closed, so we went to the Villa Roma. The Villa Roma served exactly what the children liked—pasta with butter—and afterward I drove everyone around behind the restaurant to take a look at the D&H repair shed that I had photographed a little over a year before. The pile of road salt was gone, but a large hole had been punched into the side of the building and an RV was parked inside. The building, I thought, would soon be gone. After we left, I kept thinking about the old repair shed and wishing I had taken a picture of it, and when I e-mailed Daphne Kingsley in December I told her about it. I didn't know if I'd hear back from her—our e-mails were becoming less and less frequent—but she wrote back right away.

 She was living on a biodynamic farm in northern California, working, as she wrote, harder than she ever had in her life. But she was happy and learning a lot, and had "become involved in a beautiful friendship with another person living on the farm, Cameron." Right now, however, she was back in Whitehall for Christmas and would be there until the second week of January. "I don't want to see my hometown be taken over by the corporate world like every other run-down town in America," she wrote. "Do you want me to go and take a picture of the building with a hole in it? I don't claim any experience as a photographer, but I could try to capture what you see." A couple of weeks later a roll of film arrived at my office in New York. What I liked best about the photograph I eventually chose was that it included not only the building with the hole in it but Daphne herself.

Acknowledgments

I wish first of all to thank Daphne Kingsley for her extraordinary generosity in allowing me to base so much of this book on her. I am indebted to her as guide, inspiration, and friend. Her father Orson, her mother Kim, her uncle Richard, and her husband Cameron Genter also contributed enormously, allowing me to speak with them, sometimes at great length, about their family, their town, and upstate New York.

 Others who shared their time and knowledge, and without whom this book could not have been made, include Elizabeth Barnett, who inspired us at the Millay Colony with her dramatic accounts of Edna St. Vincent Millay's life; Quentin Beaver, manager of the Fort Salem Theatre, who gave me permission to photograph one of the many shows he produces and directs there; George Colbert, who initially helped me chart the course of Route 22 in Manhattan; Kristen DeLuca, who spoke to me about her life and family; Jacob Desautels, now a sergeant in the U.S. Army, who posed with his friends one afternoon in Plattsburgh; Nancy Duniho, who sold me some useful books that same afternoon in Plattsburgh; Ray and Linda Faville, hospitable owners of the Lock 12 Marina, who often talked with me about their lives and Whitehall; Carol Greenough, who also talked with me about her life and Whitehall and kindly allowed me to photograph in the Skenesborough Museum; Jerry and Tom Laribee, who showed me a new use for tripods; Joanne Kessler, whose tour of Skene Manor included useful asides on the history of Whitehall; Bijan Mahoodi and Barbara Arpante, who told me about the Millay colony; Brenna Miller and Amanda Darrah, who taught me about mourning wreaths; Will Moses, who spoke to me about his town and his work, and allowed me to photograph one of his paintings; Jean O'Hara and her family, who introduced me unforgettably to the Shakers of Mount Lebanon and allowed me

to photograph there; Carl Pratt, who talked to me about his cows, his barn, and his house; William Skerritt of the New York State Department of Transportation, who helped me track down the early history of Route 22; and Olivia Sumerlin of Hoosick Falls, who called me just as this book was about to be printed to tell me that in 2003, as sometimes happens when a new furnace is installed improperly, flames engulfed her British School of Ballet and it burned to the ground. She is in the process of rebuilding.

Friends who assisted at various stages and in numerous ways include Tom Fels, Morgen Fleisig, Matthew Gaddis, Stanley Greenberg, Frederick Kaufman, Anne Lafond, Steve Lerner, Mary Ellin Lerner, Richard Lewis, Elizabeth Matson, Michel Negroponte, John Nordell, Elizabeth Peters, George Prochnik, Tim Tompkins, and Harry Wilks. My fellow residents at the Millay Colony, Angie Cruz, Ian Honeyman, Linn Meyers, Nancy Reisman, and Lyn Bell Rose encouraged me at the start, while my mother-in-law, Mary Ellin Barrett, and father-in-law, the late Marvin Barrett—mentors both—kept me at it the rest of the time.

It was my father who first put a camera into my hands and my mother who first pointed the way up Route 22. To both of them, as well as to my grandmothers, Catharine Smith and the late Randall Chanler, I am grateful for their love and support throughout the project. My sisters, Sarah Swett and Lyn Miller, share with me a sense of Route 22 as more than just a road.

Certain people were especially helpful in guiding the book toward publication. These include: Martha Hopewell and Gail Giles, former executive and admissions directors of the Millay Colony; Gina Occhiogrosso and Ken Salzmann, artistic and publicity directors at the Arts Center for the Capital Region in Troy; Gwenn Mayers

and the directors and staff at the Spencertown Academy; the directors and staff at the Sand Lake Center for the Arts; Richard Roth, of the *Berkshire Independent*; and Joan Davidson, president of Furthermore. Ms. Davidson and Ann Birckmayer, administrator at Furthermore,
with Sharon Palmer and the Columbia County Historical Society, gave grants at a crucial time.

To my agent, Timothy Seldes, I raise my glass for having directed me to such a wise and imaginative publisher as Jim Mairs. I am indebted to Jim and to the entire Quantuck Lane team including copy-editor Don Kennison, master designer Laura Lindgren, and Austin O'Driscoll for turning my tentative ideas into a stunning book.

To my wife, Katherine, thank you for supporting me through every stage of this strange and unexpected journey. You have given me encouragement where it was most needed and criticism where it was most useful. You and our children, Rachel, Nicky, and Willie, are and always will be my favorite traveling companions.